Pierre Bonnard

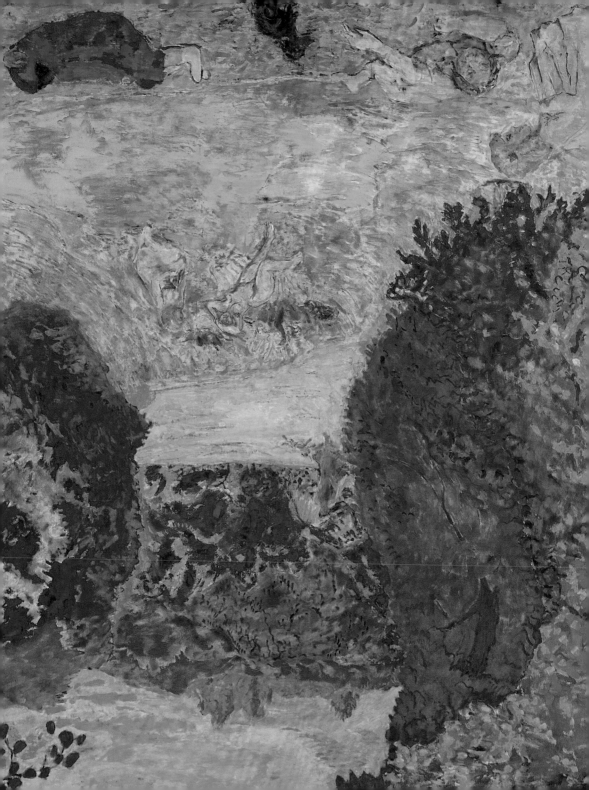

Pierre Bonnard

Juliette Rizzi

'If it's harmonious it will be true – colour, perspective, etc. We copy the laws of our vision – not the objects.'[1]

Pierre Eugène Frédéric Bonnard was born on 3 October 1867 in Fontenay-aux-Roses, in the south-west outskirts of Paris. His father, François Eugène Bonnard (1837–1895), came from the Dauphiné region and worked as a chief clerk in the war ministry, and his mother, Elizabeth Lélia Mertzdorff (1840–1919), came from the region of Alsace. Pierre was the middle child of three, the elder brother being Charles (1864–1941) and the younger sister Andrée (1872–1923). Pierre spent most of his childhood between Fontenay-aux-Roses and Paris, as well as at his family's countryside house, 'Le Clos', at Le Grand-Lemps in the Dauphiné, close to La Côte-Saint-André, in the region of Isère (fig.2). The house, which originally belonged to his grandfather, a grain merchant named Michel Bonnard, was surrounded by a vast garden and ten acres of woods, and beyond a variety of landscapes that characterised the region: small valleys, deep lakes and waterfalls, clearly defined flat plains.[2] The young Bonnard enjoyed taking walks in these natural surroundings.

From 1875 to 1885, after attending a boarding school in Vanves, Bonnard studied at the prestigious Lycée Louis-le-Grand and Lycée Charlemagne in Paris. The young pupil enjoyed philosophy, Latin and Greek, as well as modern literature, making illustrations in the margins of a copy of an edition of seventeenth-century French writer Jean de La Fontaine's *Fables*. Bonnard displayed an early interest in drawing and painting during these years, but was also an excellent academic student, attaining a Bachelor's degree in Classics. Shortly after attending classes at the École des Arts Décoratifs, he decided to reject the idea of becoming a professional artist and instead painted only in his spare time.[3] Bonnard enrolled at the Faculty of Law in Paris, following the wishes of his father, and lived initially with his maternal

1. Portrait of Pierre Bonnard, reproduced in *Verve* 1947
Photograph by Rogi André

grandmother, Caroline Mertzdorff (1812–1900), of whom he made several portraits, and whose encouragement was instrumental in support of the young Bonnard's vocation for the arts, even alongside his law degree. In 1887, Bonnard decided to enrol at the Académie Julian, a private art school in Paris, where he met artists Paul Sérusier (1864–1927), Maurice Denis (1870–1943), Henri-Gabriel Ibels (1867–1936) and Paul Ranson (1864–1909). Then, while still continuing his studies at the Faculty of Law, he attended the École des Beaux-Arts in Paris for one year and there met Ker-Xavier Roussel (1867–1944) and Édouard Vuillard (1868–1940), with the latter becoming a very close friend.[4] In 1888, Bonnard obtained his law degree and began working part-time at a registry office in Courbevoie, a suburb of Paris, but he would continue to return frequently to the family house at Le Grand-Lemps, where he painted a number of small-scale landscapes (fig.3) depicting the natural surroundings, which were reminiscent of the idyllic landscapes of artist Jean-Baptiste-Camille Corot (1796–1875) (fig.4). In a letter to his mother dated 20 July 1888, Bonnard warned: 'Do not imagine I am coming to [Le Grand-] Lemps just to sit around and observe. I am going to bring a load of canvases and pigments and I plan to paint from morning till night.'[5] Bonnard's passion for painting had begun to take hold.

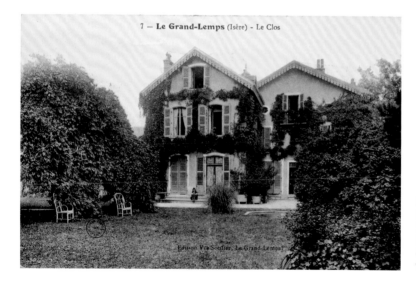

7 — **Le Grand-Lemps** (Isère) - Le Clos

2. The home of the Bonnard family at Le Grand-Lemps, 1890. Photographer unknown. Collection: Louis Fournier-Virieu

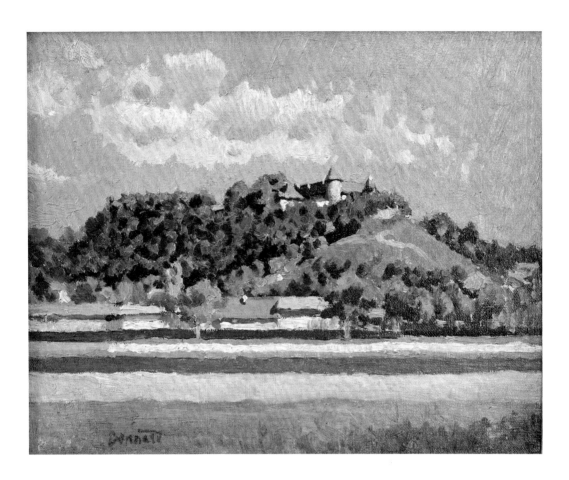

3. Pierre Bonnard
*The Castle of Virieu,
in Dauphiné* c.1888.
Oil paint on canvas
22 × 27
Private collection

That same year Bonnard's friend, Paul Sérusier, met the artist Paul
Gauguin (1848–1903) in Pont-Aven, Brittany, and upon his return to
Paris showed Bonnard a small painting, *The Talisman, the Aven River
at the Bois d'Amour* 1888 (fig.5) that he had produced under Gauguin's
guidance, emphasising flat areas of bold colour. Sérusier explained
that Gauguin had taken him to the landscape and had asked: 'What
colour do you see that tree? Is it green? Then use green, the finest
green on your palette. And that shadow? It's blue if anything? Don't be
afraid to paint it as blue as you possibly can.'[6] This encounter proved
crucial to both artists, with Bonnard and Sérusier then forming the
group known as 'Nabis'[7] (from the Hebrew, meaning 'prophets') in
order to pursue and extend Gauguin's ideas on painting: a return to
essentials, the purity of colour, simplicity of form. The group were also

admirers of artists such as Odilon Redon (1840–1916) (fig.6), Gustave Moreau (1826–98) and Puvis de Chavannes (1824–98). Bonnard, who was still developing his own style at that time, frequently visited the Louvre with his friend Édouard Vuillard (1868–1940) and took inspiration from the work of his contemporaries, such as Claude Monet (1840–1926), Pierre-Auguste Renoir (1841–1919) and Henri Matisse (1869–1954), but influence also came from farther afield; Japanese prints had begun to circulate in the Western market at that time, and their style corresponded very much to what the group were seeking, transposing elemental lines and avoiding a mere copy of the real (fig.7). Bonnard started collecting Japanese woodcuts and printed crêpe paper, and the artist himself eloquently described the dramatic influence they would have on his future work: '[…] I understood immediately from those crude images that colour could express all things without needing modelling or relief. It seemed to me then that it was possible to translate light, form, and character with nothing more than colour.'[8]

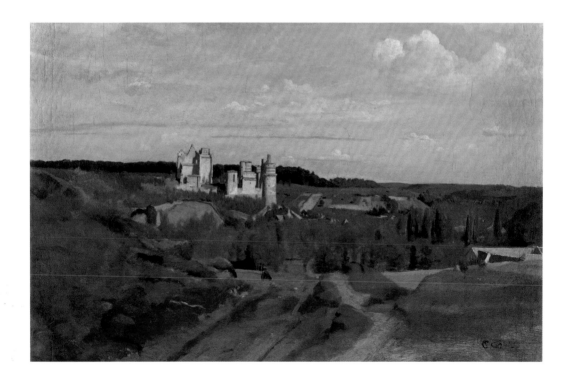

4. Jean Baptiste Corot (1796–1895)
View of the Pierrefonds Castle 1840–5
Oil paint on canvas
51.5 × 77.9
Musée des Beaux-Arts de Quimper

5. Paul Sérusier
(1863–1927)
*The Talisman, the Aven
River at the Bois d'Amour*
1888
Oil paint on wood
27 × 21
Musée d'Orsay, Paris

Moreover, this interest in Japanese prints prompted Bonnard's first breakthrough as a professional artist – in printmaking rather than painting. After a period of military service, he returned to Paris, renting his first studio at rue Le Chapelais, in the Batignolles neighbourhood,[9] and won first prize in a competition for a poster advertising a popular brand of champagne, earning 100 francs.[10] The poster, *France-Champagne*, 1891 (fig.8) was reminiscent of the Eastern influence, and when hung on the walls of Paris attracted much attention.[11]

That same year Bonnard left the registry office to work for the Paris courts as a public prosecutor of the Seine, and meanwhile continued to develop his painting style. Léon-Paul Fargue remarked: 'He paints slowly, with this obvious yet secretly feverish indifference that we have always known in him.'[12] The artist then rented a studio with friends Vuillard and Denis, and actor Aurélien Lugné-Poe (1869–1840), and his relationships within the art world in Paris broadened. He would regularly contribute, alongside other notable artists, writers and musicians, to the bi-monthly avant-garde literary magazine *La Revue Blanche*, published by Thadée and Alexandre Natanson, who would become great friends and patrons throughout Bonnard's career (fig.9).[13] In 1890, his sister Andrée married Claude Terrasse, a friend, composer and music teacher with whom Bonnard collaborated on a number of illustrations and posters related to Terrasse's compositions and performances.

Bonnard's first exhibition, *Peintres Impressionistes et symbolistes* at the Galerie Le Barc de Boutteville in Paris, was in 1891 as part of the Nabis group, and was quickly followed by the artist himself showing five paintings and four decorative panels titled *Women in the Garden* 1891 (fig.10) at the Salon des Indépendants, an institution with which

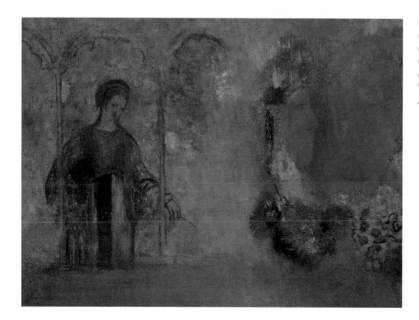

6. Odilon Redon
Gothic Arcade: Woman with Flowers c.1905
Oil paint on canvas
43.5 × 60.8
Van Gogh Museum, Amsterdam

7. Utagawa Kuniyoshi
Historical Scene,
Tokiwa Gozen, lover of
Minamoto no Yoshibune
Nineteenth century
Japanese woodcut print
35.5 × 24.5
Private collection
Former collection of
Pierre Bonnard

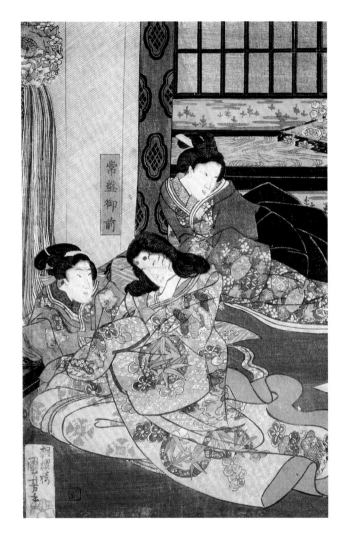

he would go on to collaborate until the end of his life. However, Bonnard was never completely comfortable with the teaching of the Beaux-Arts or with the constraints of a group, and craved independence: 'I do not belong to any school. I am only trying to do something personal, and I am trying to unlearn, at this moment, what I worked so hard to learn during the four years at the École des Beaux-Arts.'[14] It was at this time that he decided to dedicate himself more purposefully to painting.

'... under the sign of the uncertain'[15]

In 1893, Bonnard's personal life took a crucial turn; following the refusal of his marriage proposal by his cousin Berthe Schaedlin in the previous year, he met Maria Boursin (1869–1942), who was working at the Maison Trousselier making artificial flowers. She went by the name Marthe de Méligny and was to become Bonnard's model, muse and partner, playing a hugely significant role as a subject in his work.

Meanwhile, Bonnard's artistic career was taking off, including commissions by Ambroise Vollard, who had recently opened a gallery in rue Laffitte and exhibited the work of Manet. It was a time when, like many artists, Bonnard was working on or engaging in a number of different fronts, due to the developments of the art nouveau movement and the increasing entanglement of art and life at the end of the century: furniture projects, theatre projects, stained glasses, screens, tapestries, sculpture. He also had the chance around that

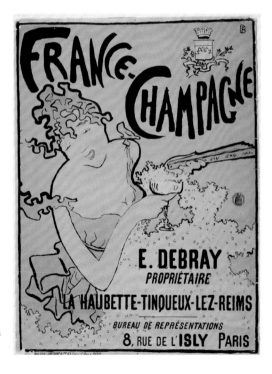

8. Pierre Bonnard, poster
France-Champagne 1891
Lithograph
79 × 58.6 (sheet)
Museum of Modern Art,
New York

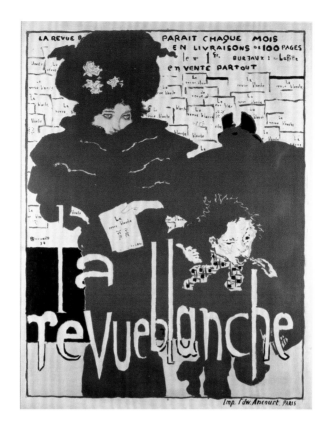

9. Poster for *La Revue Blanche* 1894
Lithograph
80 × 62
The Higgins Art Gallery &
Museum, Bedford

time to meet the inventors of cinema, Auguste and Louis Lumière from Lyon, who spent time at Bonnard's family home in Le Grand-Lemps; at this time Bonnard began to experiment with photography, a medium that played an important role in his practice, albeit then considered a secondary medium.

Then followed another artistic epiphany, which Bonnard later explained to Raymond Cogniat: 'It was during a vacation in the Dauphiné [...] The year was around 1895. One day, the words and theories that were the foundation of our conversations – color, harmony, the relation between line and tone, balance – lost their abstract significance and became very concrete. I had understood what I was seeking and how I would try to obtain it. What came after? The point of departure had been given to me; the rest was just daily life.'[16]

Bonnard's first one-man show was in 1896 at the Durand-Ruel gallery, where he exhibited fifty-five works including lithographs, paintings and billboards. The art critic Gustave Geffroy remarked: 'A curious line in movement, of a monkey-like suppleness, captures these casual gestures of the streets, these fleeting expressions born and vanished in an instant. It is the poetry of a life that is past, the remembrance of things, of animals, of human beings.'[17] However, the show was initially not well received by friend and artist Camille Pissarro (1830–1903),[18] who wrote to his son that he found it 'hideous' and a 'complete fiasco'.[19] Their judgement was to be revised later that year, as Renoir commented regarding Bonnard's illustrations for the Danish novel *Marie* 1898, by Peter Nansen, '… absolutely exquisite … Hold on to this art'.[20]

These were years of experimentation, with the Nabis group pursuing a variety of artistic directions with great enthusiasm, but in exploring different art forms Bonnard had yet to find his own path. Up to this point Bonnard's paintings had explored simple subjects such as animals, family scenes at Le Grand-Lemps and the everyday life of the city of Paris at the height of its development. Then at the end of the century his palette darkened, perhaps influenced by the style of his friend Vuillard, and he devoted a number of paintings to interior scenes with a focus on the female nude, a subject that would endure as one of the most important in his oeuvre. These paintings were retrospectively considered 'intimiste', including paintings such as *The Indolent* 1899 (fig.22) or *Man and Woman* 1900 (fig.23). Bonnard revealed his relationship with de Méligny to the public, with all its nuances of emotional and erotic tension as well as a sense of solitude. Having seen *The Indolent* at the Durand-Ruel gallery, the art dealer Ambroise Vollard commissioned Bonnard to illustrate *Parallèlement* 1900 (fig.11), a book of verse by the recently deceased Paul Verlaine, but the lithographs were not well received by the critics due to their peculiar format. Nevertheless, soon after, Vollard commissioned some other illustrations with the more classical subject of *Daphné and Chloé* (published in 1902); Bonnard repaid Vollard's faith with exquisite, lyrical designs.

Bonnard had travelled internationally in 1899, when he went on a trip to Venice and Milan with his friends Vuillard and Roussel, but it was around 1900, after moving into his new studio at 65 rue Douai,

10. Pierre Bonnard
Women in the Garden 1891
(one panel of four)
Oil paint on paper,
mounted on canvas,
decorative panel
160 × 48
Musée d'Orsay, Paris

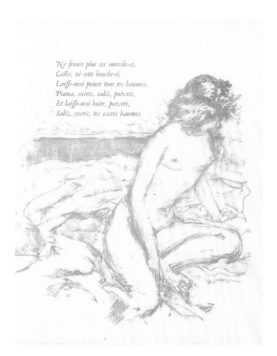

that he started to leave Paris more often.[21] Like the impressionists, he and de Méligny went to the countryside along the Seine Valley, to Montval, Vernouillet, Médan and elsewhere. He also regularly spent summer and early autumn at Le Grand-Lemps, returning to Paris in the winter. During these trips between Paris and Normandy he mainly painted landscapes, exploring the change of light and trying to capture the atmosphere of northern French scenery. It was a time when he also experimented with portraiture and sculpture under the influence of Aristide Maillol (fig.13).[22] Then, after ten years together in Paris, the Nabis gradually dissolved and moved away; Denis to Saint-Germain-en-Laye, Roussel to L'Étang-la-Ville; Maillol to Marvy-le-Roi.

In the coming years, the Bernheim-Jeune gallery in Paris was to become the centre of the French avant-garde. Bonnard started his collaboration with the gallery in 1906, having a one-man show each year, and the relationship would provide the artist with an income until the end of his life.[23] However, Bonnard did not actively engage with new developments in art, such as fauvism and later cubism with the

rise of Matisse and Picasso; he commented on the arrival of cubism as leaving him 'hanging in midair',[24] its structural codes not lending much to the sensations and perceptions that Bonnard cherished so dearly. At the same time, although he always admired the work of the impressionists he had always considered their work too objective; as Thadée Natanson described, Bonnard 'detests above all to let himself be tied down by anyone, to be attached or enclosed anywhere […]'.[25] He combined the ideas of the impressionists with the influence of the work of Cézanne in his treatment of the object, exploring how to transpose light onto canvas. To that end, in 1909, Bonnard joined the artist Henri Manguin (1874–1949) in Saint-Tropez and remained astonished by the light in the Midi: 'I was struck […] the sea, the yellow walls, the reflections coloured as much as the light …'[26] This would be

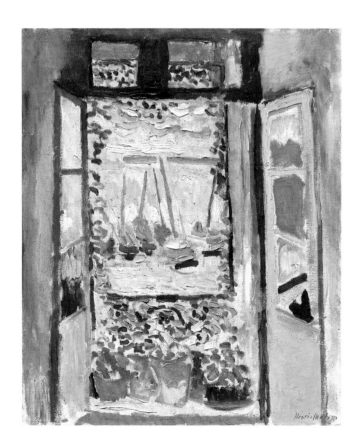

12. Henri Matisse (1869–1954) *The Open Window at Collioure* 1905
Oil paint on canvas
55.3 × 46
National Gallery of Art, Washington

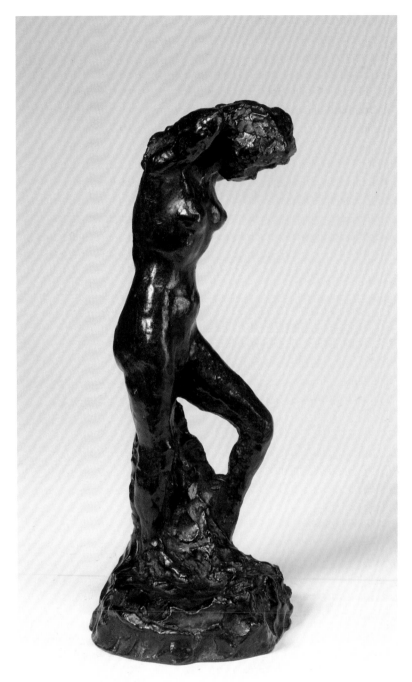

13. Pierre Bonnard
Woman Bathing c.1900–6
Bronze
27.3 cm (height)
Hirshhorn Museum
and Sculpture Garden,
Smithsonian Institution,
Washington DC

the first of many trips to the south of France to pursue enquiries into colour and light which would become so fundamental to his work,[27] and on such excursions he would later meet Paul Signac (1863–1935) and visit Renoir (1841–1919). Bonnard's work became embedded with the sensibility expressed by the impressionists, but this culminated in something of a crisis in his practice; for a number of years he tried to reflect on what he had produced so far and how to overcome his dissatisfaction. One of the solutions Bonnard devised was to develop a certain structure in his paintings, controlled by framing devices such as doors, mirrors, and horizonal and vertical lines between which colour and light could then be accommodated (fig.25). Despite these excursions, and despite Montmartre remaining his favourite neighbourhood, in which he rented a new atelier at 22 rue Tourlaque, from 1912 Bonnard spent most of his time in the outskirts of Saint-Germain-en-Laye and his summers in Vernonnet, close to Vernon in Normandy. There he bought a small villa, 'Ma Roulotte', and would pay regular visits to Claude Monet in nearby Giverny. In the same year, at an exhibition at Bernheim-Jeune, Bonnard bought the work by Matisse *The Open Window at Collioure* 1905 (fig.12).[28]

'I have all my subjects to hand. I go and look at them. I take notes. Then I go home. And before I start painting, I reflect. I dream.'[29]

During the First World War Bonnard worked for long periods at the villa of Polish artist Józef Pankiewicz (1866–1940) in Saint-Tropez. The conflict was not directly reflected in Bonnard's work,[30] perhaps in part because he and de Méligny were increasingly forced to lead a rather secluded life; de Méligny suffered from a tuberculosis-related disease, and by the 1920s the couple would pay regular visits to spas along the Atlantic coast in search of a cure, largely to the exclusion of family and friends. For months at a time Bonnard would continue his work from temporary studios[31] in hotels or rental properties, made possible because his continued thirst for observation and transcription of nature was expounded using a particular approach; he would almost never paint in front of the subject, instead making notes and drawings in sketchbooks during his walks in the country that he used as aides-memoires when returning to his atelier to paint.

During this period he travelled to Rome with Renée Monchaty, whom he had met in 1916 and who modelled for him while de Méligny remained in Saint-Tropez. Shortly after Bonnard married de Méligny in Paris in 1925, at a small ceremony and without the knowledge of the family, Monchaty took her own life.

Bonnard's predilection for the south became increasingly important, to the point where the couple bought a house in Le Cannet, near Cannes, calling it 'Le Bosquet' (fig.14). The property was surrounded by a thriving garden which would feature in many of Bonnard's works in the years to come, and the view overlooked the red roofs of Le Cannet, the sea and the mountains of the Esterel. His atelier was on the first floor, and it is there that he produced his most renowned masterpieces of the 1920s and 1930s, considered the pinnacle of his work. Among the first visitors to Le Bosquet were the Hanhloser family, great collectors and friends of Bonnard. The son recalled: 'Every spring ... Bonnard usually pinned his entire winter's work to the walls of the studio at the Villa du Bosquet. Then he invited us to tea, which was served in various old cups, and my parents were allowed to say what they liked in particular, but in no case could they acquire a new canvas. Only if the chosen work was still liked by Bonnard the next year, even if it had been completely altered, were my parents allowed to take it away, otherwise Bonnard would simply make it disappear.'[32] Commissions for paintings could take years as Bonnard rethought, re-imagined and revisited his canvases a number of times.[33]

In 1925 Bonnard painted *Nude in the Bath* (fig.42) and *The Bath* (fig.43), both examples of the peculiar choice of viewpoint and simultaneity of human presence and absence that he was exploring in this period.[34] Bonnard continued to paint from memory; at the end of the 1920s he used a number of diaries in which he would draw, write and express preoccupations with art, which, alongside the sketchbooks, were also used as aides-memoires.[35] As they were highly portable, he could carry these diaries with him constantly, and annotate and draw in them spontaneously (fig.15).

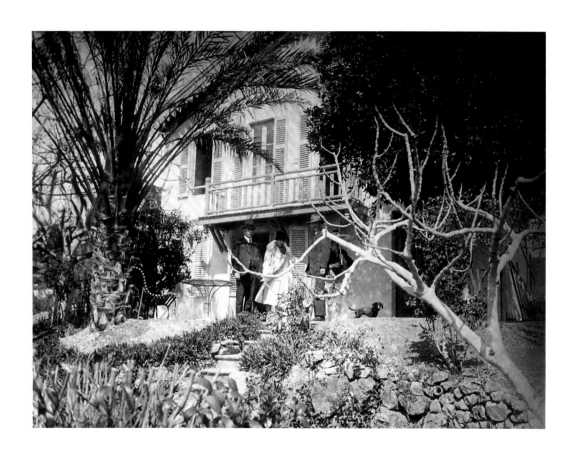

14. Bonnard with Arthur
and Hedy Hahnloser in
front of 'Le Bosquet',
Le Cannet, c.1927.
Photographer unknown.
Archives Hahnloser

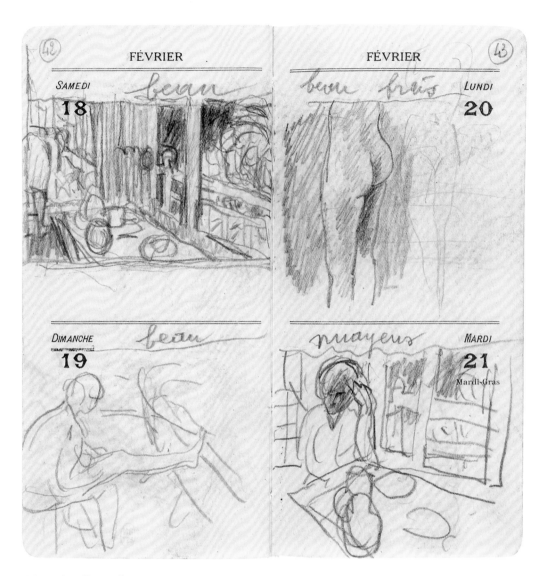

15. Pages from Bonnard's
diaries (18–21 February
1928) showing sketches
and annotations.
13.5 × 7.5
Bibliothèque Nationale
de France

'Purple in the greys. Vermilion red in the orange shadows, on a cold clear day.'[36]

After a trip to the United States in 1926,[37] towards the end of the decade and into the beginning of the 1930s, Bonnard's investigation into colour and light was elevated to a new level in the public sphere. He held two major exhibitions at the beginning of 1933, one at Bernheim-Jeune, where he exhibited twenty-six recent paintings, and the other at Galerie Braun, Paris, exhibiting thirty-one. His friend and artist Paul Signac commented on the show at Bernheim-Jeune: 'Prodigious. The unexpected, the rare, the new, I swear to you, my dear Bonnard, that since 1880, when I "discovered" Claude Monet, I have never had such a deep feeling of Art.'[38] Notwithstanding this praise, it could be said that Bonnard's art was not particularly 'of the time'; scenes from the everyday and interiors with windows and doors looking onto lush landscapes conveyed a sense of escapism, nostalgia or *reverie* (*Large Dining Room*, fig.50).

Meanwhile, his life with de Méligny was becoming more and more secluded due to her misanthropic attitude, with the artist using this isolation to deepen his research into painting techniques. From the end of 1934 until the outbreak of war, the couple spent long periods along the English Channel, on the Normandy coast in Trouville, Benerville and Deauville, where Bonnard found the changes in light and skyscapes particularly attractive, and worthy of transposition into a number of paintings of that time. He continued to alternate his stays between Vernon and Le Cannet, and would have a number of successful exhibitions abroad, in New York at the Wildenstein gallery and in London in 1936 at the Reid and Lefevre gallery, as well as in Stockholm, Brussels and Amsterdam. Around this time, he also met for the first time the future gallerist Aimé Maeght (1906–81), who would become one of his most fervent supporters, and a friend. [39]

At the beginning of 1938 Bonnard sold his house in Vernon and spent two months in Paris, and for the duration of the war stayed in his villa, Le Bosquet. Notwithstanding the obvious horrors of the war, which affected the artist greatly, this was a difficult period in Bonnard's life. The death of his friend Vuillard in 1940, and his brother Charles a year later in Algeria, caused him great sorrow, and the closing of the Bernheim-Jeune gallery under duress from

the German authorities was a significant loss professionally.[40] Most significantly, perhaps, de Méligny passed away on 26 January 1942. Bonnard shared his feelings with Matisse, with whom he continued to correspond and meet: 'Imagine my sorrow and my solitude, filled with bitterness and worry about what kind of life I can still lead.'[41]

The artist would nevertheless find solace in his art, and continued working with vigour throughout the period, including on his last major interior, *The Studio with Mimosa* 1939–46 (fig.59), and on a commission for the church of the Plateau d'Assy in Savoie (fig.16). Bonnard also agreed to work on a catalogue raisonné of his work in oil, which was compiled by Jean and Henri Dauberville and was somewhat motivated by the increased circulation of fakes; even today this constitutes a crucial source.[42] He continued to exhibit in the United States and in Paris, with a number of art magazines dedicating issues and articles to his work, and photographers making photo-reportages in his studio.[43] This burgeoning success did not

16. Pierre Bonnard at home in Le Cannet, France 1944 Photograph by Henri Cartier-Bresson

17. One of the walls in Pierre Bonnard's studio, Le Cannet, France 1944 Photograph by Henri Cartier-Bresson

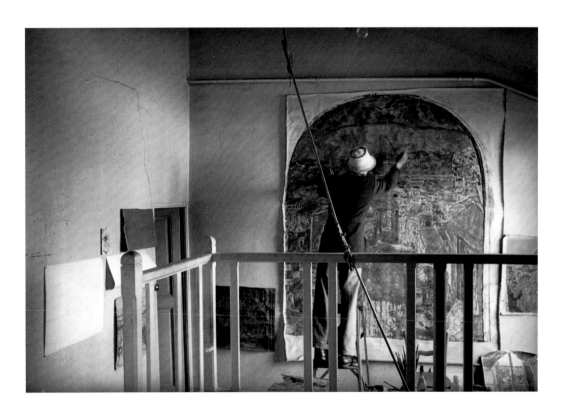

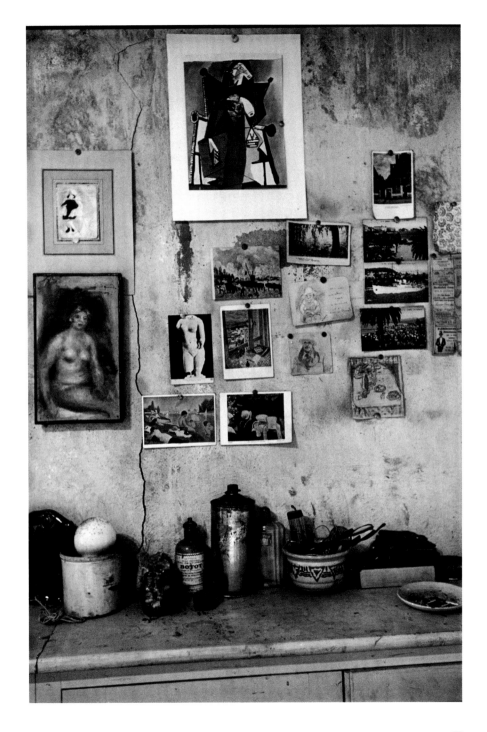

seem to affect Bonnard's work particularly, and seemingly neither did the events of the outside world;[44] he withdrew into his practice, continuing to paint the view from his garden at Le Cannet (fig.55). However, Bonnard's work did gradually move towards abstraction, as noted in 1944 by the magazine *Formes et Couleurs*: 'As opposed to the furious spontaneity of two innovators, Matisse and Picasso, [Bonnard] offers a slow, a patient technique of constantly adding new brushstrokes over those of the preceding day [...] As his works become saturated with increasingly rich tones, they also move towards abstraction . . .'[45]

'Colour, the key to every painting'[46]

After the war, Bonnard went back to Paris where he had retained his atelier in rue Tourlaque, and designed the cover for an issue of *Verve*[47] (fig.18) while exhibiting at the reopened Bernheim-Jeune. He then

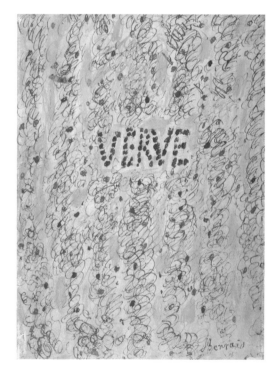

18. *Verve* 1947
British Library

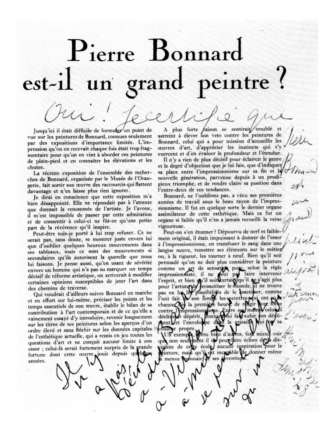

agreed to a major retrospective to be organised by the Museum of Modern Art, New York, in celebration of his eightieth birthday, which took place in Cleveland and New York between March and September 1948, to great critical acclaim. Bonnard worked and reworked until the end, painting his last work *Almond Tree in Blossom* 1947 (fig.60) a few days before he passed away. Dissatisfied with a shade of green in the bottom corner of the painting, he asked his nephew Charles Terrasse to paint over it in yellow. Bonnard died in Le Cannet in January 1947, and the first posthumous retrospective exhibition of his work was held in Paris at the Musée de l'Orangerie in October that year. Perhaps the most prestigious and unambiguous tribute was paid by his great friend Matisse: 'I certify that Pierre Bonnard is a great painter, for today and assuredly for the future'(fig.19).[48]

20. *The Game of Croquet*
1892
Oil paint on canvas
130 x 162.5
Musée d'Orsay, Paris

21. *Self-Portrait* 1899
Oil paint on canvas
21 x 15
Private collection

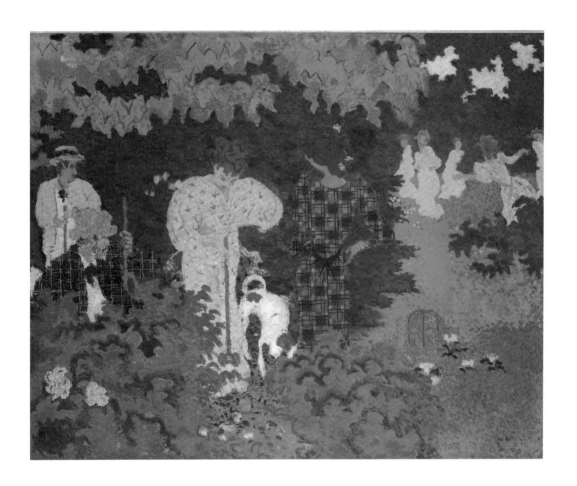

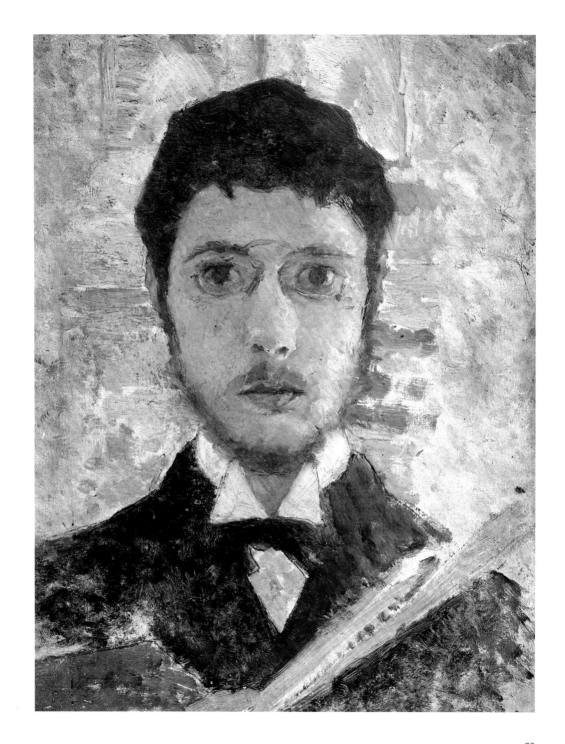

22. *The Indolent* 1899
Oil paint on canvas
96.4 × 105.2
Musee d'Orsay, Paris

23. *Man and Woman* 1900
Oil paint on canvas
155 × 72.5
Musée d'Orsay, Paris

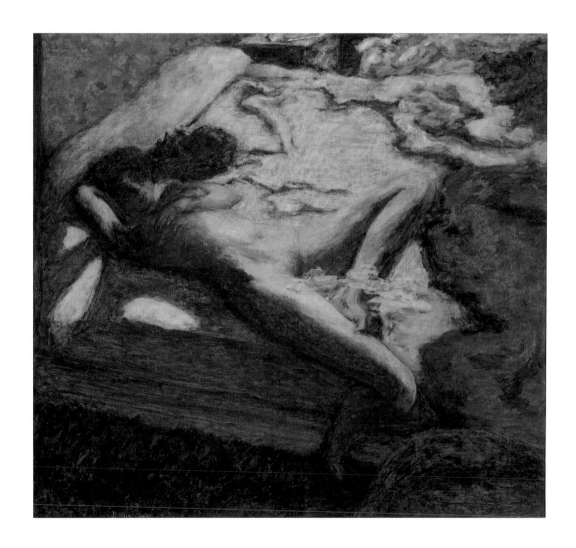

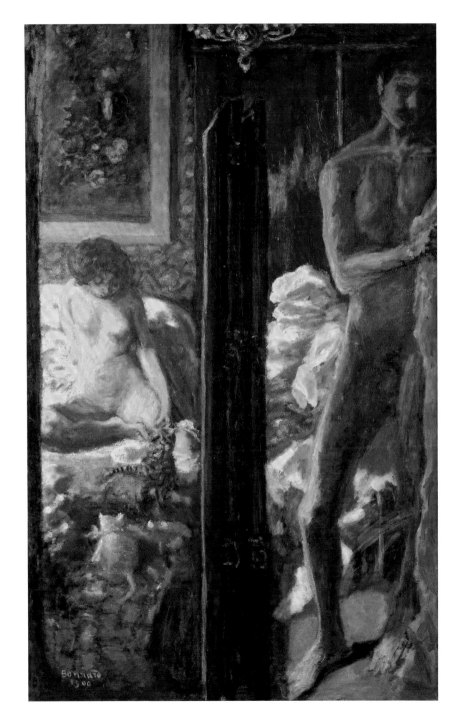

24. *Mirror above a
Washstand* 1908
Oil paint on canvas
120 × 97
The Pushkin State
Museum of Fine Arts,
Moscow

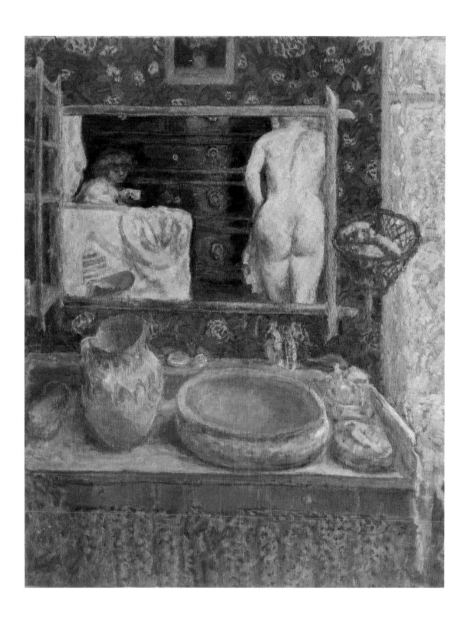

25. *Open Window towards
the Seine (Vernon)* 1911
Oil paint on canvas
78 × 113
Musée des Beaux-Arts,
Nice, France

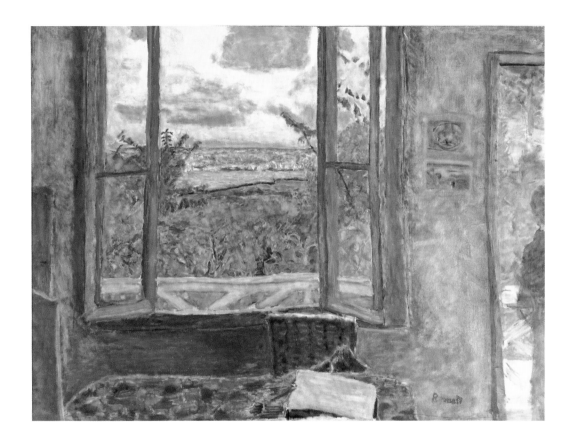

26. *La Place de Clichy* 1912
Oil paint on canvas
138 × 203
Musée National d'Art
Moderne – Centre
Pompidou, Paris /
Musée des beaux-arts et
d'archéologie de Besançon

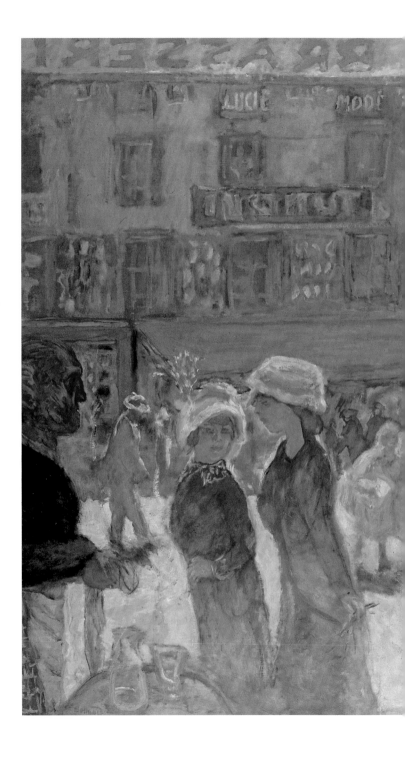

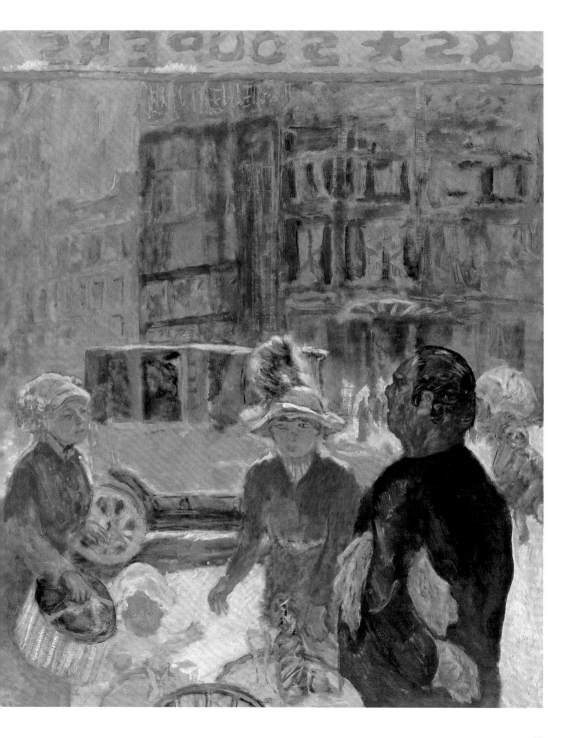

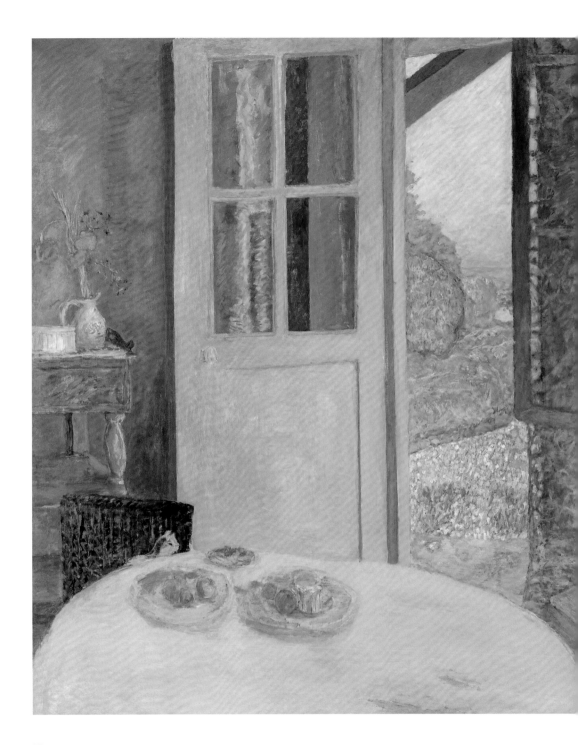

27. *Dining Room in the Country* 1913
Oil paint on canvas
164.5 × 205.7
Minneapolis Institute
of Art, USA

28. *The Mantlepiece* 1916
Oil paint on canvas
81 × 111
Private collection

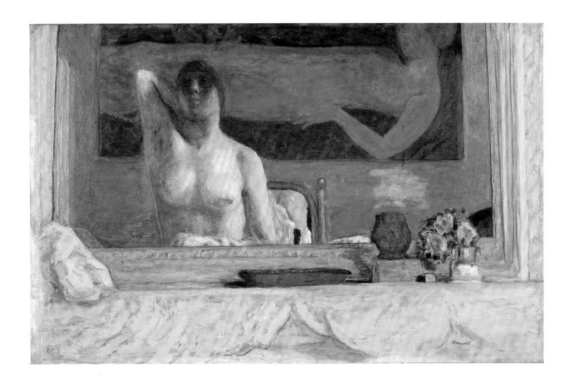

29. *A Village in Ruins near Ham* 1917
Oil paint on canvas
63 × 86
Centre national des arts plastiques, Paris

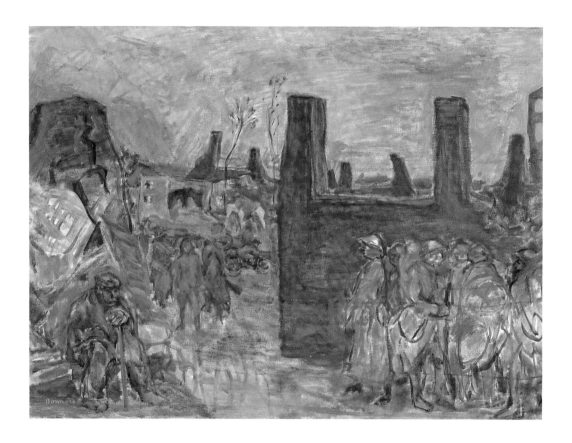

30. *Summer* 1917
Oil paint on canvas
260 × 340
Fondation Marguerite
et Aimé Maeght,
Saint-Paul, France

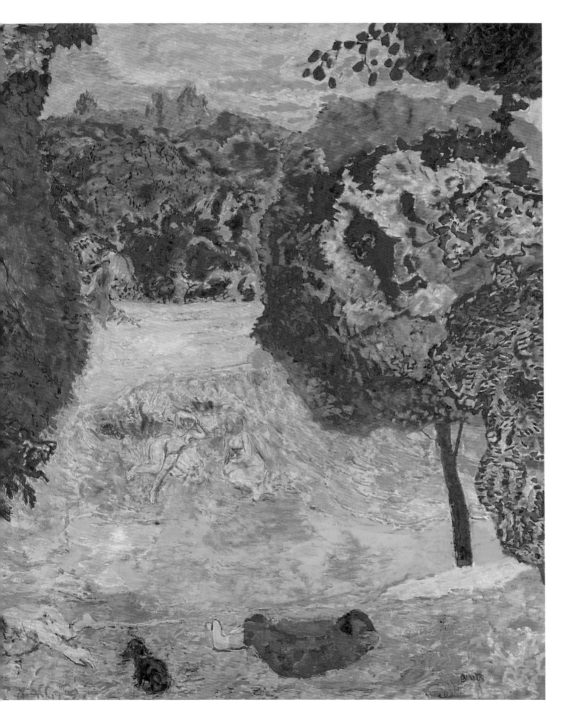

31. *Nude Crouching
in the Tub* 1918
Oil paint on canvas
83 × 74
Musée d'Orsay, Paris

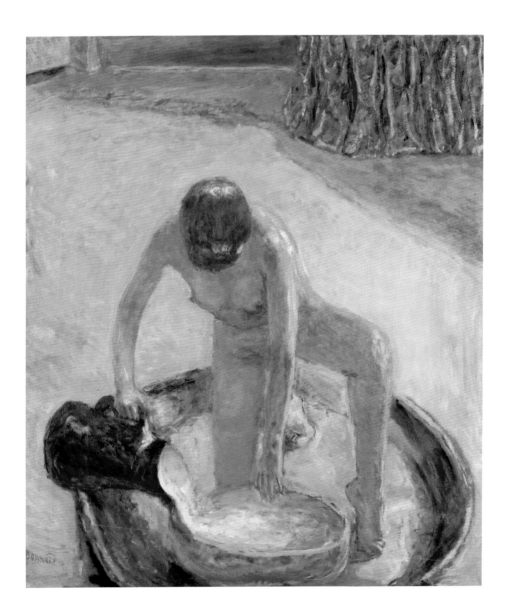

32. *Sunlight at Vernonnet*
1920
Oil paint on canvas
47.5 × 56.2
Amgueddfa Cymru –
National Museum Wales,
Cardiff, UK

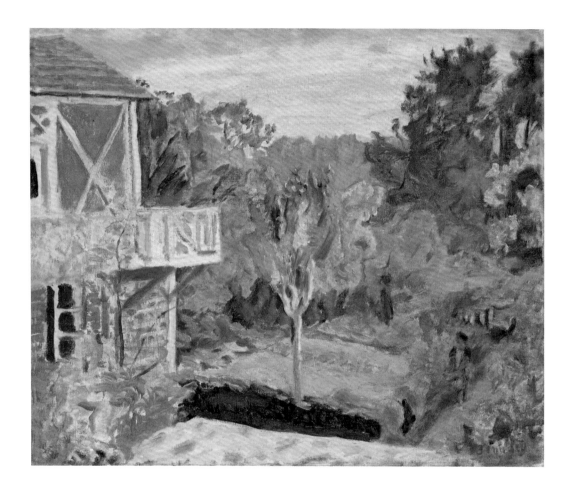

33. *Pastoral Symphony*
1916–20
Oil paint on canvas
130 × 160
Musée d'Orsay, Paris

34. *The Toilette* 1914/1921
Oil paint on canvas
119 × 79
Musée d'Orsay, Paris

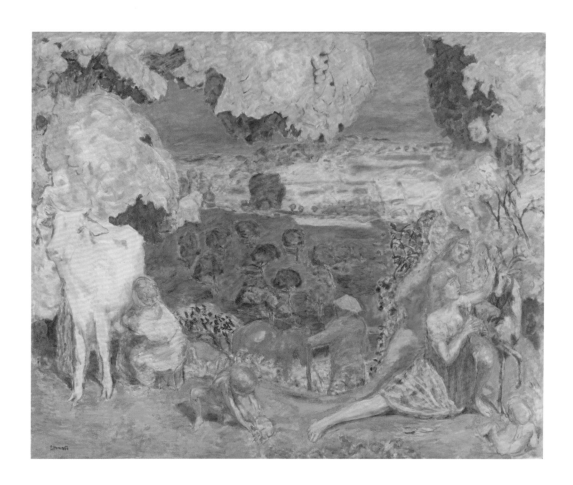

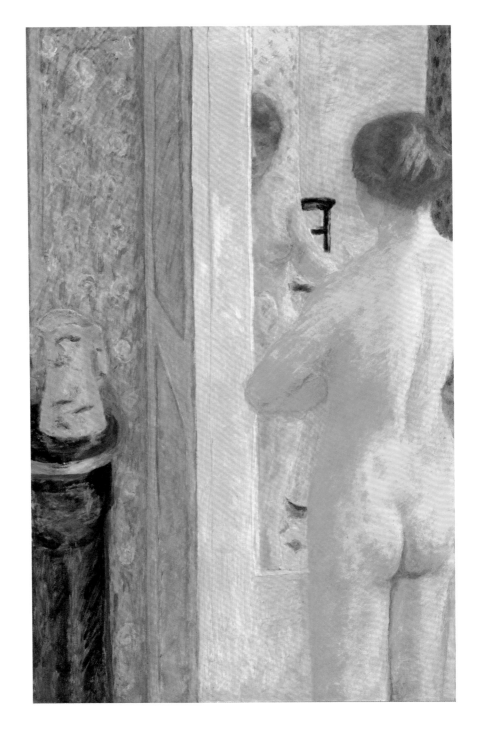

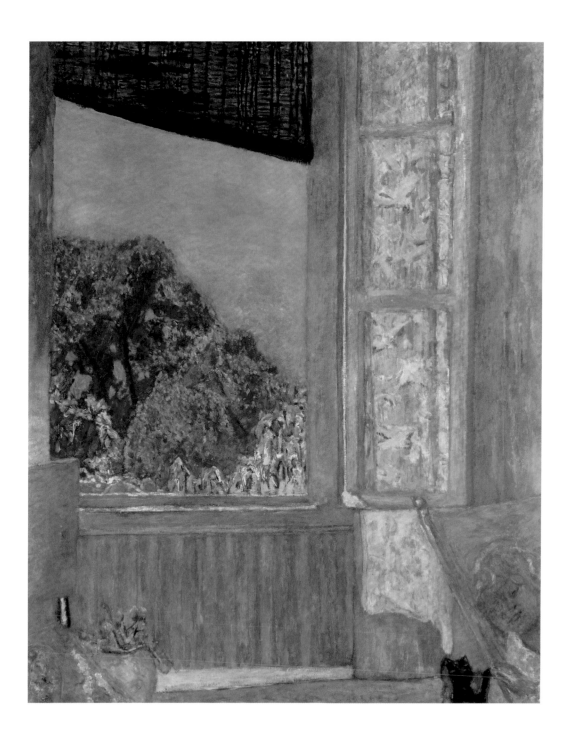

35. *The Open Window*
1921
Oil paint on canvas
118.1 × 96
The Phillips Collection,
Washington DC

36. *Piazza del Popolo,
Rome* 1922
Oil paint on canvas
79.5 × 96.5
Private collection

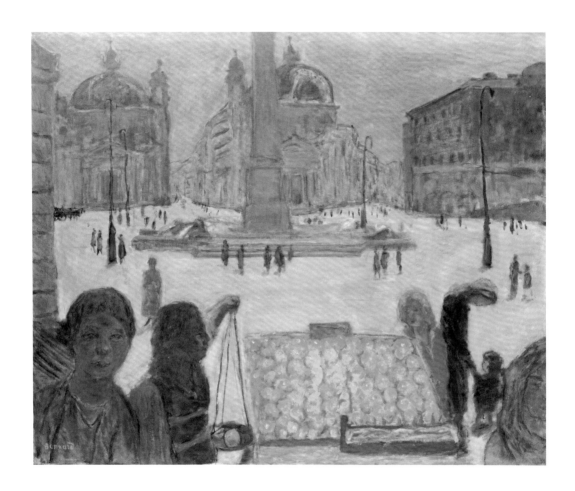

37. *Still Life* 1922
Oil paint on canvas
43.5 × 47
Fitzwilliam Museum,
University of Cambridge

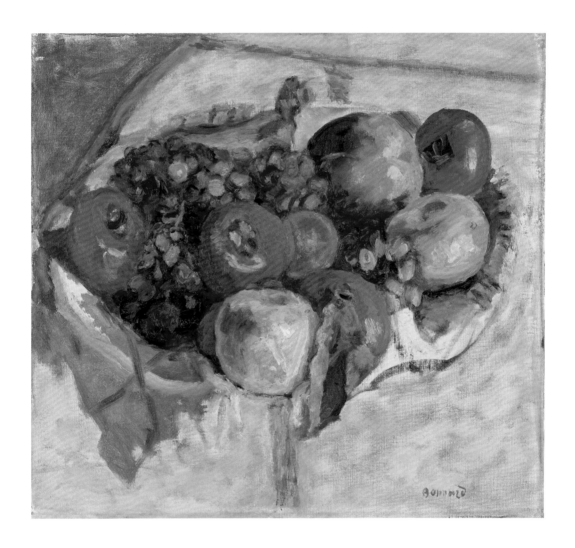

38. *The Door Opening onto the Garden* c.1924
Oil paint on canvas
109 × 104
Private collection

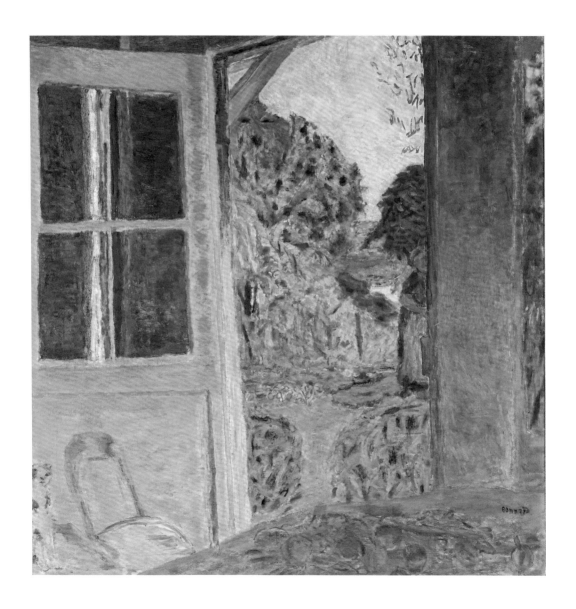

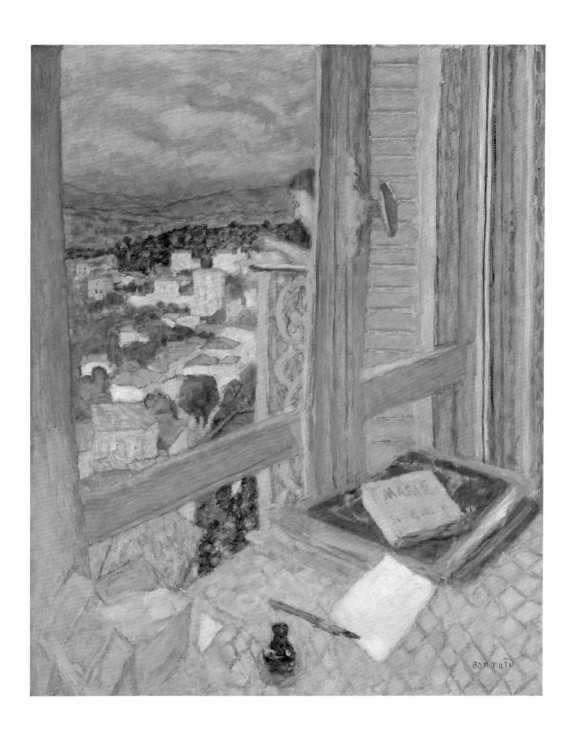

39. *The Window* 1925
Oil paint on canvas
108.6 × 88.6
Tate

40. *The White Tablecloth*
1925
Oil paint on canvas
100 × 109
Von der Heydt Museum,
Wuppertal, Germany

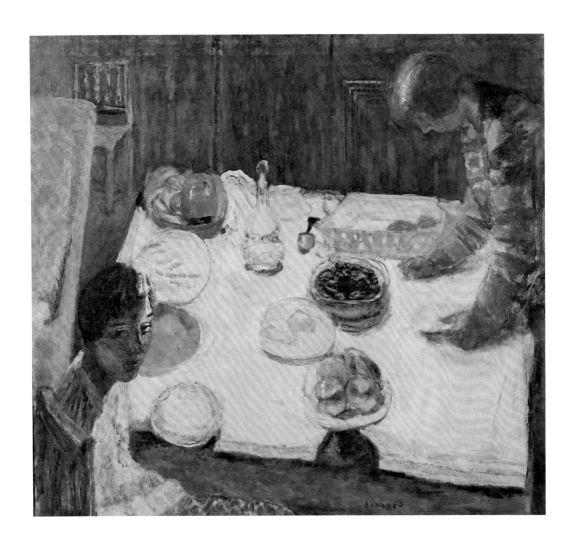

41. *The Dining Room,
Vernon* 1925
Oil paint on canvas
126 × 184
Ny Carlsberg Glyptotek,
Copenhagen

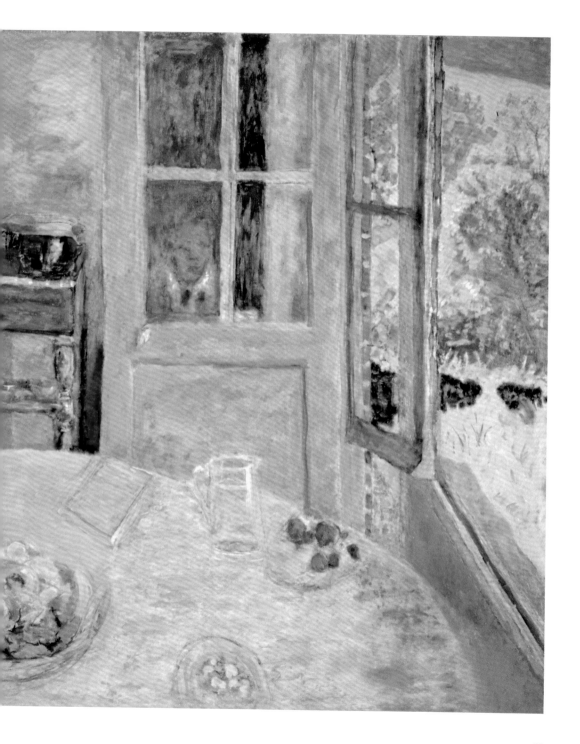

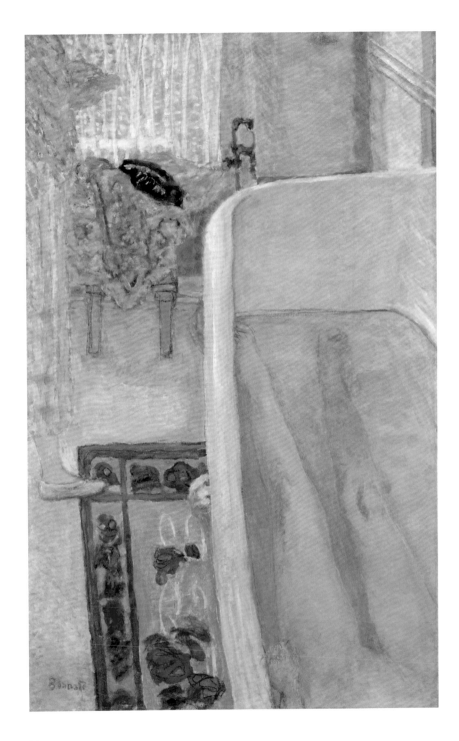

42. *Nude in the Bath* 1925
Oil paint on canvas
104.8 × 65.4
Tate

43. *The Bath* 1925
Oil paint on canvas
86 × 120.6
Tate

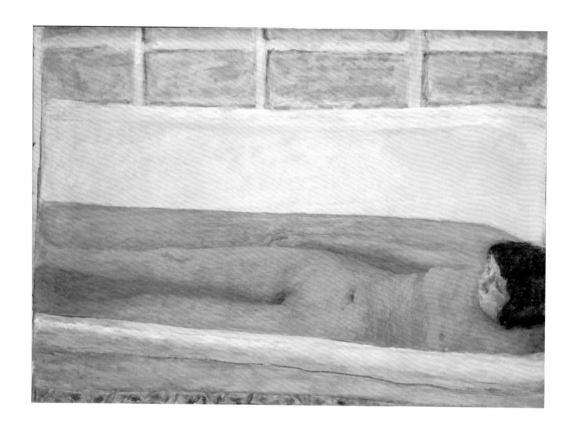

44. *Basket of Bananas* 1926
Oil paint on canvas
60 × 64.1
Metropolitan Museum
of Art, New York

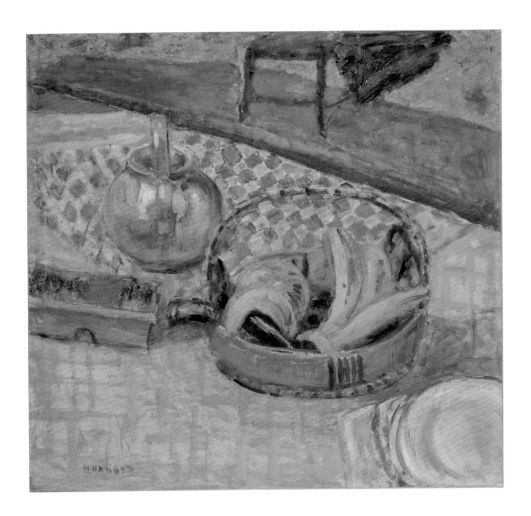

45. *Landscape at Sunset*
(Le Cannet) c.1927
Oil paint on canvas
105 × 117
Kunsthaus Zürich,
Switzerland

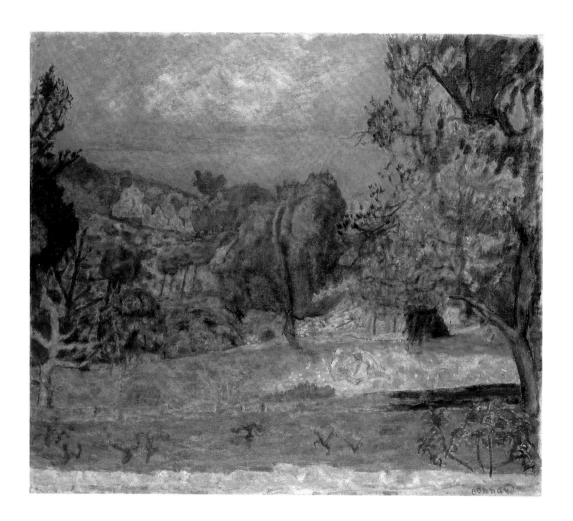

46. *Nude in the Mirror* 1931
Oil paint on canvas
153.5 × 104.3
Fondazione Musei
Civici Venezia, Italy

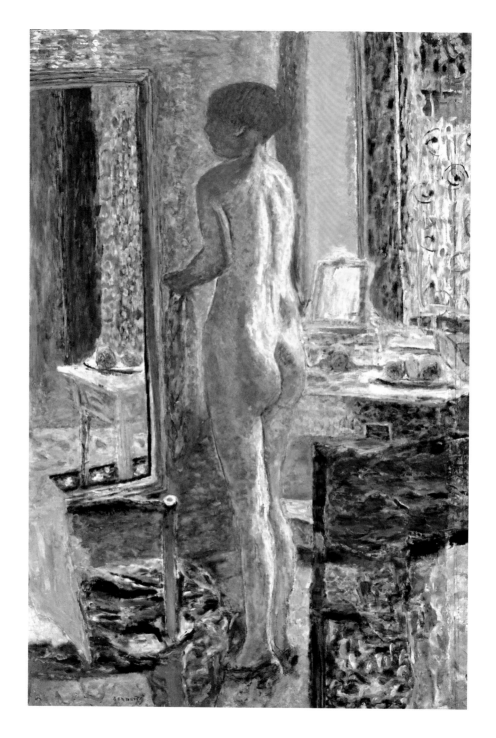

47. *The Boxer* 1931
Oil paint on canvas
54 × 74.3
Musée d'Orsay, Paris

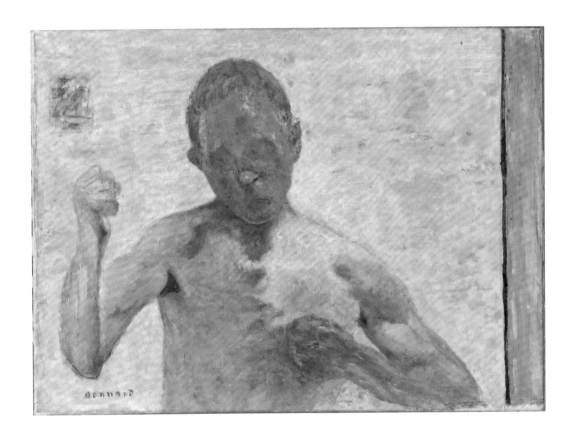

48. *Nude in the Bathroom*
1932
Oil paint on canvas
121 × 118.1
Museum of Modern Art,
New York

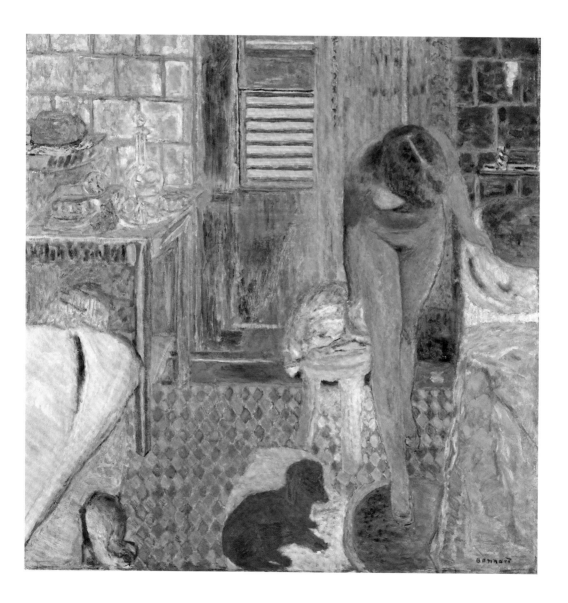

49. *The French Window*
1932
Oil paint on canvas
86 × 112
Private collection

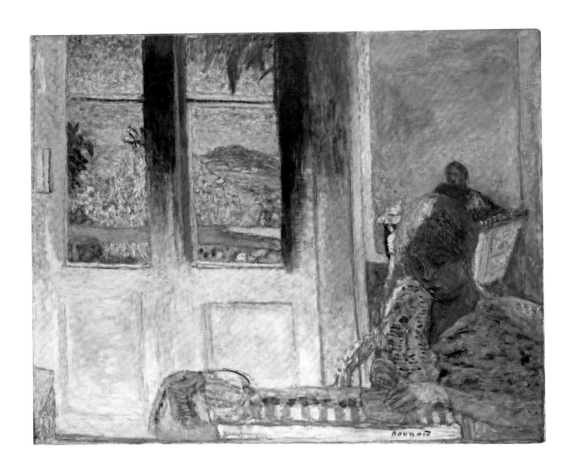

50. *Large Dining Room
Overlooking the Garden*
1934–5
126.8 × 135.3
Solomon R. Guggenheim
Museum, New York

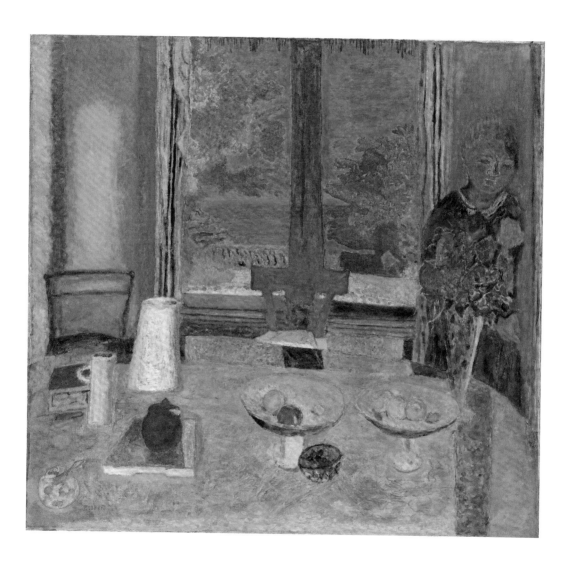

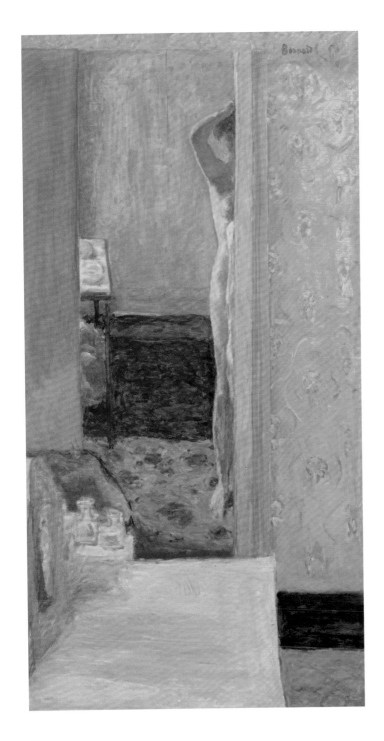

51. *Nude in an Interior*
c.1935
Oil paint on canvas
134 × 69.2
National Gallery of Art,
Washington

52. *Nude in the Bath* 1936
Oil paint on canvas
93 × 147
Musée d'Art moderne
de la Ville de Paris

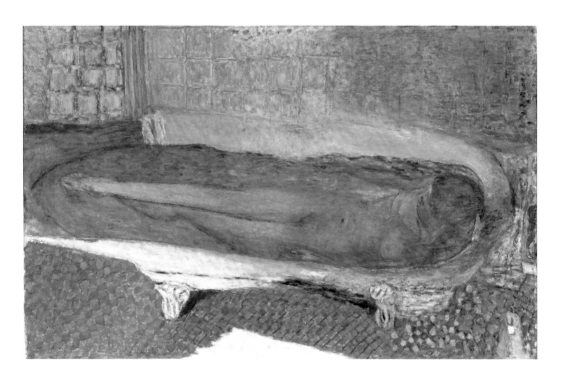

53. *The Garden* 1936
Oil paint on canvas
127 × 100
Musée d'Art moderne
de la Ville de Paris

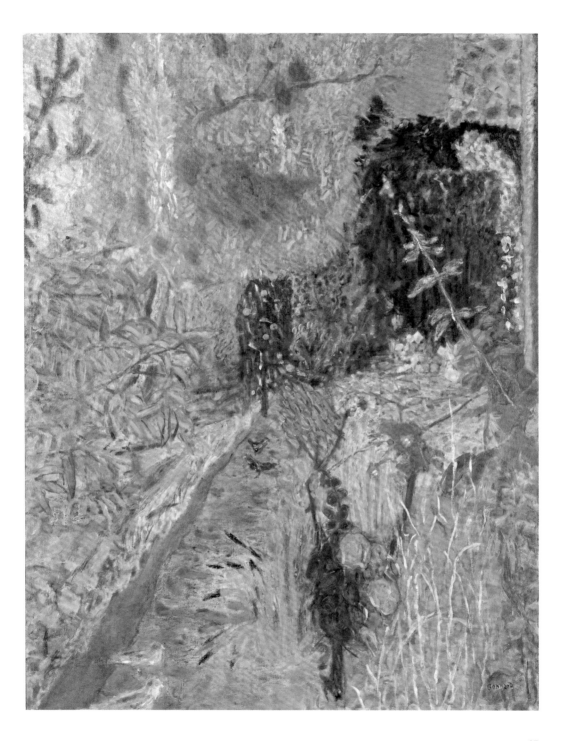

54. *Seashore, Red Field*
c.1939
Oil paint on canvas
34.5 × 50
Private collection

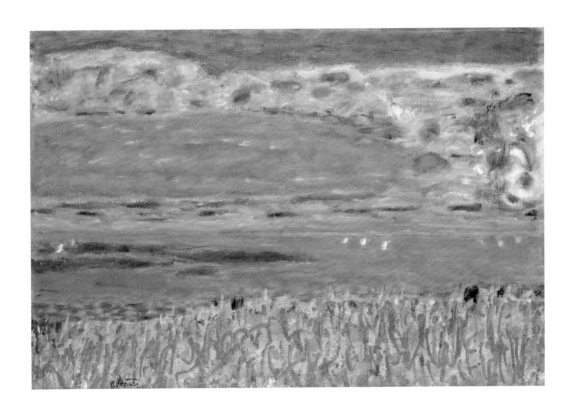

55. *Panoramic View of Le Cannet* 1941
Oil paint on canvas
80 × 104
Private collection

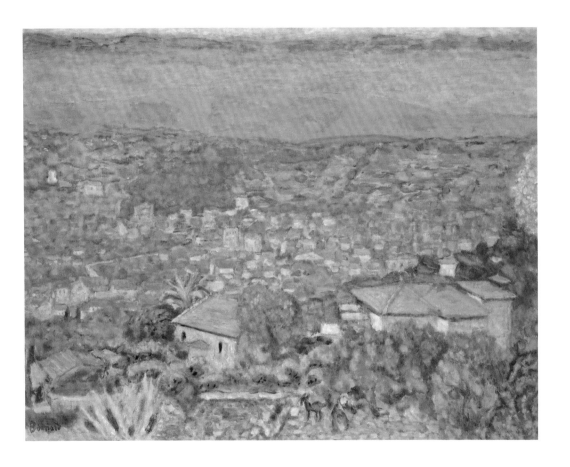

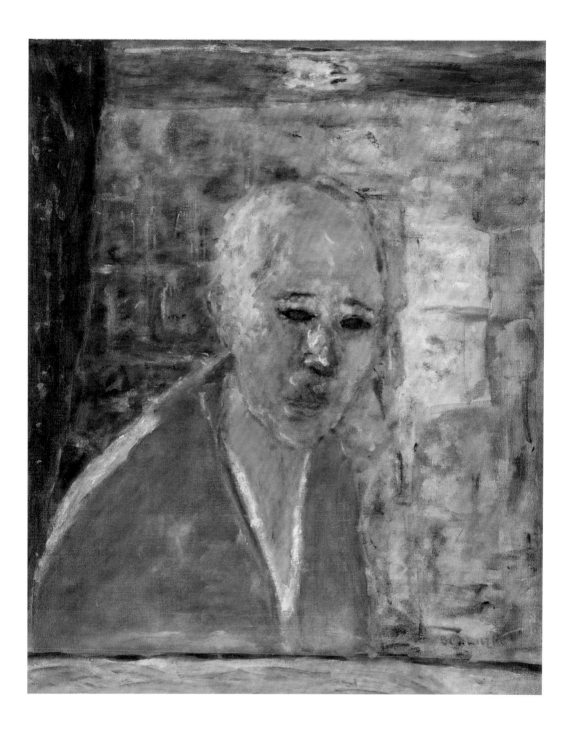

56. *Self-Portrait* 1945
Oil paint on canvas
55.5 × 46
Fondation Bemberg,
Toulouse, France

57. *Bathers at the End
of the Day* c.1945
Oil paint on canvas
48.7 × 69.7
Musée Bonnard,
Le Cannet, France

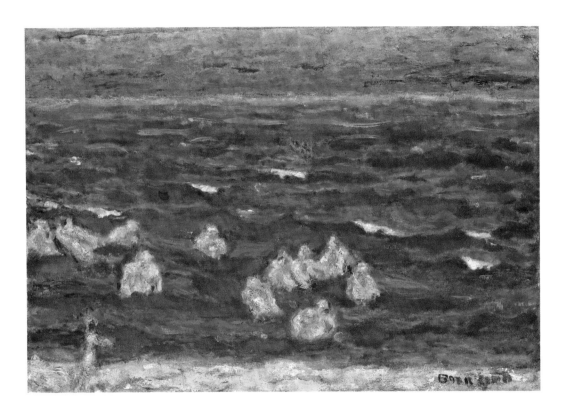

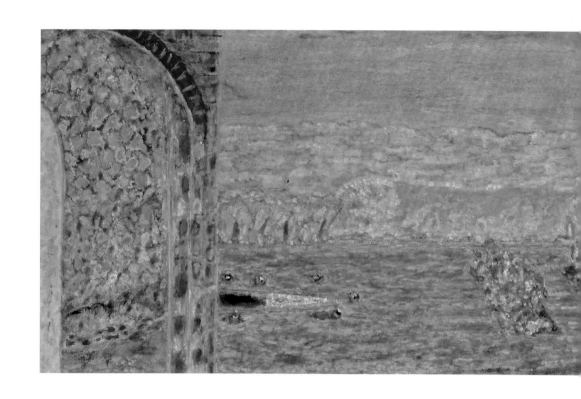

58. *The Sunlit Terrace*
1939–46
Oil paint on canvas
71 × 236
Private collection

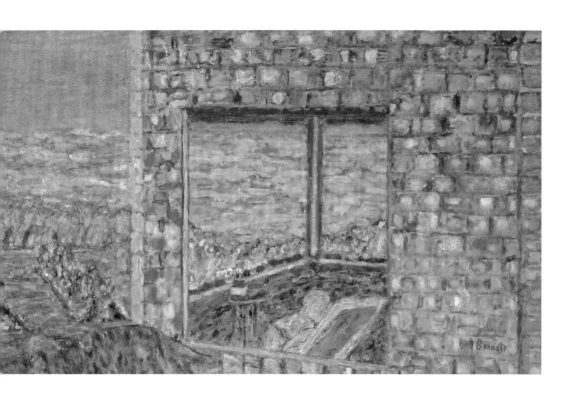

59. *The Studio with Mimosa* 1939–46
Oil paint on canvas
127.5 × 127.5
Musée national d'Art moderne – Centre Pompidou, Paris

60. *Almond Tree in Blossom* 1946–7
Oil paint on canvas
55 × 37.5
Musée d'Orsay, Paris

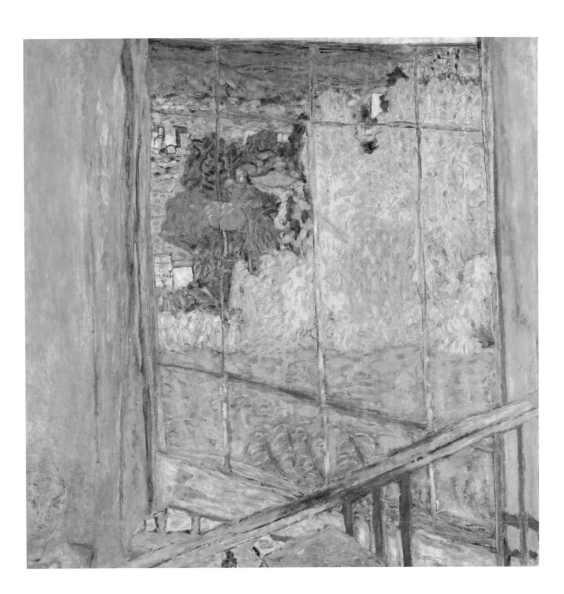

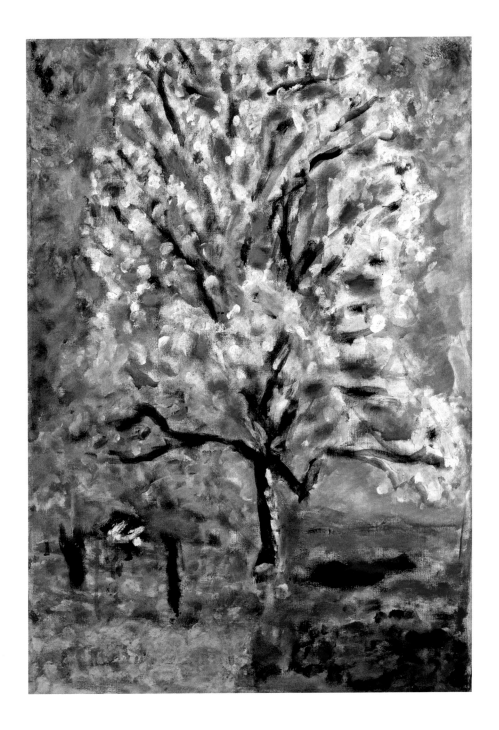

Notes

1. 8 January 1928 in Pierre Bonnard, *Observations sur la peinture*, Preface by Alain Lévêque and Introduction by Antoine Terrasse, *L'Atelier contemporain*, (ed) François-Marie Deyrolle, Strasbourg, 2015, p.26.
2. Antoine Terrasse, *Pierre Bonnard*, Editions Gallimard, Paris, 1967, p.15.
3. Bonnard wrote to his father in November 1885: 'Now that I have given up the idea of earning a living from painting, it strikes me as the most wonderful thing. I am going to devote all my spare time to working at it seriously …' Elsa M. Smithgall with a contribution by Lisa Lipinski in *Pierre Bonnard: Early and Late (Chronology)*, The Phillips Collection, Washington DC, 2002, p.26 and Antoine Terrasse, *Bonnard: Shimmering Color*, trans. Laurel Hirsh, Harry N. Abrams, New York, 2000, p.16.
4. Vuillard and Bonnard began corresponding in 1891.
5. Quoted in Smithgall, *Chronology*, p.27 and Terrasse, *Shimmering Color*, p.16.
6. Maurice Denis 'L'Influence de Paul Gauguin', *L'Occident*, October 1903, quoted in Nicholas Watkins, *Bonnard: Colour and Light*, London: Tate Gallery Publishing, 1998, p.32 and in Elizabeth Hutton Turner, 'The Imaginary Cinema of Pierre Bonnard', in *Pierre Bonnard: Early and Late*, The Phillips Collection, Washington DC, 2002, p.54.
7. The Nabis group constituted Pierre Bonnard, René Piot, Henri-Gabriel Ibels, Maurice Denis, Édouard Vuillard, Ker-Xavier Roussel and Paul Ranson. They were joined in 1891 by Jan Verkade, in 1892 by Félix Vallotton, and then Georges Lacombe, Mogens Ballin, József Rippl-Rónai, Charles Filiger, Adolf Robbi and Aristide Maillol.
8. Gaston Diehl 'Bonnard dans son univers enchanté', *Comoedia*, no. 106, 10 July 1943, n.p., and in Elizabeth Hutton Turner, 'The Imaginary Cinema of Pierre Bonnard', in *Pierre Bonnard: Early and Late*, The Phillips Collection, Washington DC, 2002, p.54.

9. He would change apartments and studios a number of times throughout his career.
10. This was the first artistic project for which Bonnard earned some money.
11. In particular it was noticed by the artist Henri de Toulouse-Lautrec (1864–1901), whom Bonnard took to the printer Ancourt and with whom Toulouse-Lautrec realised his first project for the Moulin Rouge. Félix Fénéon had coined the epithet 'Bonnard, le nabi très japonard' to refer to the artist. In Ursula Perucchi-Petri, 'Japonisme in Bonnard's Early and Late Work', in *Pierre Bonnard: Early and Late*, The Phillips Collection, Washington DC, 2002, p.190.
12. 'Il peignait avec cette lenteur, cette indifférence apparente mais secrètement fiévreuse que nous lui avons toujours connue' quoted in Terrasse, *Pierre Bonnard*, Editions Gallimard, Paris, 1967, p. 20 and Smithgall, *Chronology*, p.28.
13. Bonnard made the first advertising poster for *La Revue Blanche* in 1894.
14. 'Bonnard', excerpt from interview in Jacques Daurelle, 'Chez les jeunes peintres', *L'Echo de Paris*, 28 December 1891, 2, quoted in Helen Emery Giambruni 'Early Bonnard, 1885–1900', PhD. diss., University of California, Berkeley, 1983, p.75 and in Smithgall, *Chronology*, p.29.
15. Bonnard, *Observations sur la peinture*, p.31.
16. Quoted in Raymond Cogniat, 'Les Nouvelles artistiques', translated in Terrasse, *Bonnard: Shimmering Color*, pp.126–7 and in Smithgall, *Chronology*, p.31.
17. *Le Journal*, 8 January 1896 quoted in Max Kozloff, 'Pierre Bonnard: From Impressionism to Abstraction', MA thesis, University of Chicago, 1956, p.57 and in Elizabeth Hutton Turner, 'The Imaginary Cinema of Pierre Bonnard', in *Pierre Bonnard: Early and Late*, The Phillips Collection, Washington DC, 2002, p.58.

18. And others, such as Puvis de Chavanne, Degas, Renoir and Monet.
19. Camille Pissarro to Lucien Pissarro, 31 January 1896, *Correspondance de Camille Pissarro*, vol.4, 1895–1898, ed. Janine Bailly-Herzberg, Editions de Valhermeil, Paris, 1980, p.158 and in Elizabeth Hutton Turner, 'The Imaginary Cinema of Pierre Bonnard', in *Pierre Bonnard: Early and Late*, The Phillips Collection, Washington DC, 2002, p.59.
20. Julian Bell, *Bonnard*, Phaidon Press Limited, London, 1994, p.13. Bonnard recalled these words later on, after forty years.
21. Bonnard also travelled to Spain, Tunisia, Algeria and Germany in the first decade of the twentieth century.
22. '[…] *Pour moi, je m'attarde encore en Dauphiné où je me suis lancé dans la sculpture mais je ne sais pas encore si mon produit a le moindre intérêt* […]', Jacqueline Munck, *Chronology*, in *Pierre Bonnard. La couleur radieuse*, Musée national des beaux-arts du Québec, 2016–17, p.167 and Archives Maurice Denis, Musée du Prieuré, Saint-Germain-en Laye.
23. In the same year, the dealers Gertrude and Leo Stein did acquire the work *Siesta* 1900 at the *Salon d'Automne* exhibition and hung it in their home close to Picasso's *Young Girl with Bouquet of Flowers* 1905.
24. Ingrid Rydbeck, *Chez Bonnard à Deauville*, L'Echoppe, Paris, 1992, n.p. Originally the interview was published in Swedish in *Konstrevy*, n.4, Stockholm, 1937. Quote also in Elizabeth Hutton Turner, 'The Imaginary Cinema of Pierre Bonnard', in *Pierre Bonnard: Early and Late*, The Phillips Collection, Washington DC, 2002, p.65.
25. Julian Bell, *Bonnard*, 1994, p.17.
26. Jacqueline Munck, *Chronology*, 2016–17, p.169 and in Pierre Bonnard, *Correspondances*, *Verve*, Paris, 1944, n.p.
27. Around that time, the Russian collector Ivan Morozov commissioned Bonnard to paint a triptych for the staircase of his house in Moscow through the Bernheim-

Jeune gallery. The work was exhibited in the Salon d'Automne in 1911 under the title *Mediterannean panels between columns*. The triptych was reminiscent of his early work, but was very much influenced by the light and motifs of the South of France.
28. Matisse and Bonnard were very close friends and admired each other. They exchanged letters between 1925 and 1946. They shared a common vision in art which surfaced through these letters.
29. *J'ai tous mes sujets sous la main. Je vais les voir. Je prends des notes. Et puis je rentre chez moi. Et avant de peindre je réfléchis, je rêve*' Bonnard quoted in *7 jours*, 11 January 1942, p.16, cited and translated in Sarah Whitfield, 'Fragments of an Identical World', in Sarah Whitfield and John Elderfield, *Bonnard*, exh. cat., Tate Gallery, London and Museum of Modern Art, New York 1998, p.9, n.14.
30. We know that Bonnard travelled to the Somme on the Western Front for *missions aux armées*, making some sketches, and he also painted *A Village in Ruins near Ham* 1917.
31. During his numerous trips, he used to roll his canvases on his car, a Renault 11CV , and pin them to the walls of hotels, where he could continue working on different subjects at the same time as he did in his studio.
32. Hans Robert Hahnloser, the son, quoted in Marina Ferretti Bocquillon *Bonnard photographe, Bonnard photographié*, exh. cat., Le Cannet, Espace Bonnard, 2007–8, p.24 and in Véronique Serrano, *Chronology*, in *Bonnard et Le Cannet, Dans la lumière de la Méditerranée*, Editions Hazan, Paris, 2011, p.139.
33. Vuillard and Bonnard used to visit museums together, and Vuillard used to distract the guard while Bonnard retouched his own paintings as they hung.
34. 'It is the sign of death, not dynamism, however, that marks Bonnard's last great series of bathers […]' for more details see Linda Nochlin, 'Bonnard's Bathers' in

Art in America, July 1998, pp.63–67 and 103 and *Pierre Bonnard, The Work of Art: Suspending Time*, Musée d'art moderne de la ville de Paris, Lund Humphries, Hampshire, 2006, p.205.

35. It is worth noting that some of these annotations were selected by Bonnard at the end of his life under a collection of notes titled *Observations sur la peinture*. Antoine Terrasse published these again, dated and arranged chronologically, in 1984 in the catalogue of the Bonnard exhibition at the Centre Georges Pompidou, Phillips Collection in Washington DC and the Dallas Museum of Art. Subsequently another publication appeared with two other groups of annotations, one conceived by Bonnard himself and published in 1947 (after his death) in the magazine *Verve*, and the other selected by Antoine Terrasse in 1975 and published in the catalogue 'Bonnard dans sa lumière' at the Fondation Maeght.

36. Bonnard, *Observations sur la peinture*, p.25.

37. As a member of the Carnegie International Prize jury, Bonnard visited New York, Pittsburgh, Philadelphia, Chicago and Washington, where he met the art collectors Duncan and Marjorie Phillips, who would become great collectors of his work.

38. Fiona Hesse, *Chronology*, p.164 (June 1933) in *Pierre Bonnard*, Fondation Beyeler, 2012 and in Archives Signac, Paris.

39. Aimé Maeght had a decoration and radio shop in Cannes and opened a gallery in 1937. He recalled later that 'Bonnard was the great turning point of my life, and bit by bit he became a great friend' in Yoyo Maeght, *The Maeght Family: A Passion for Modern Art*, Abrams, New York, translated from the French by Graham Edwards, 2007, p.20.

40. Gaston and Josse moved to Monte Carlo and Lyon respectively, where the latter died a year later.

41. In *Pierre Bonnard, The Work of Art: Suspending Time*, Musée d'art moderne de la ville de Paris, Lund Humphries, Hampshire, 2006 (Chronology), p. 297. 'I think that a new man has been born within Bonnard since the death of his wife Marthe. Before he was an anxious man. He was always scared of her. She kept everyone away. Yet she accepted me, saying: Matisse is so busy with his painting … I must have appeared harmless to her' cited in Henri Matisse, *Écrits et propos sur l'art*, ed. Dominique Fourcade, Paris, Hermann, 1972, p.304, note 26.

42. The catalogue raisonné was recently revised: *http://www.bernheim-jeune.com/bonnard-fr/*.

43. In 1944, Tériade published *Correspondances*, a collection of fictional letters in which Bonnard evoked memories of his life. During those years, photographers Henri Cartier-Bresson, André Ostier and Gisèle Freund visited the artist.

44. However, a comment in his diary from 17 January 1944 showed a deep sadness: 'The one who sings is not always happy'.

45. In *Pierre Bonnard, The Work of Art: Suspending Time*, Musée d'art moderne de la ville de Paris, Lund Humphries, Hampshire, 2006 (Chronology), p. 297 and in André Lhote, *Formes et Couleurs*, 1944 (special issue).

46. Bonnard, *Observations sur la peinture*, p.36.

47. The issue was published after Bonnard's death in August 1947. In addition to the cover, the artist worked on the frontispiece and chose the decorative designs and selected extracts from his diaries.

48. Note sent by Matisse to Zervos in January 1948 (Archives de la Fondation Zervos); after Christian Zervos published an article in *Cahiers d'art* titled 'Is Pierre Bonnard a great painter?', Matisse scrawled his response across the article and posted it to Zervos. At the same time, a tribute to Bonnard appeared in *Le Figaro Littéraire*. On the other hand, Picasso criticised Bonnard about colour: 'When Bonnard paints a sky, perhaps he first paints it in blue, more or less the way it looks. Then he looks a little longer and sees some mauve in it, so he adds a touch or two of mauve, just to hedge. Then he decides that maybe it's a little pink too, so there's no reason not to add some pink. The result is a potpourri of indecision […] Painting isn't a question of sensibility […]' and about compositional style '[…] the way he fills up the whole picture surface, to form a continuous field, with a kind of imperceptible quivering, touch by touch, centimetre by centimetre, but with a total absence of contrast. There's never a juxtaposition of black and white, of square and circle, sharp point and curve […]' . In Yves-Alain Bois, 'Bonnard's passivity' in *Pierre Bonnard, The Work of Art: Suspending Time*, Musée d'art moderne de la ville de Paris, Lund Humphries, Hampshire, 2006, pp.51–2 and in Françoise Gilot and Carlton Lake, *Life with Picasso*, New York, Toronto, London, McGraw Hill Book Company, 1964, pp.271–2.

Credits

Index

First published 2019 by order of the Tate Trustees
by Tate Publishing, a division of Tate Enterprises
Ltd, Millbank, London SW1P 4RG
www.tate.org.uk/publishing

A catalogue record for this book is available from
the British Library

ISBN 978 1 84976 618 0

Distributed in the United States and Canada by
ABRAMS, New York

Library of Congress Control Number applied for

Project Editor: Emma Poulter
Production: Juliette Dupire
Picture Researcher: Emma O'Neill
Design: Anne Odling Smee, O-SB Design
Cover and layout: Jade Design
Colour reproduction: DL Imaging Ltd, London
Printing and binding: Graphicom SPA, Italy

Cover: *The Window* 1925 (detail). See p.50

Frontispiece: *Summer* 1917 (detail). See pp.40–1

Measurements of artworks are given in
centimetres, height before width, before depth.